11/00

Vincent van Gogh The Painter and the Portrait

In memory of Sue Madison Shackelford

Front cover:
Self-Portrait with Grey Felt Hat, (detail), 1887-88. Oil on
canvas, 17¼ × 14¾ in. (44 × 37.5 cm). Amsterdam,
Van Gogh Museum (Vincent van Gogh Foundation).
f. 0344; jh. 1353

Back cover:
Madame Roulin and her Baby, (detail), 1888–89. Oil on
canvas, 36⅜ × 28⅞ in. (92.4 × 73.3 cm). Philadelphia
Museum of Art: Bequest of Lisa Norris Elkins.
F. 0490; JH. 1637

First published in the United States of America in 2000
by UNIVERSE PUBLISHING
A Division of Rizzoli International Publications, Inc.
300 Park Avenue South
New York, NY 10010

2000 2001 2002 2003 2004 2005 / 10 9 8 7 6 5 4 3 2 1

Printed in England

Vincent van Gogh

The Painter and the Portrait

George T. M. Shackelford

UNIVERSE

ACKNOWLEDGMENTS
and bibliographical note

I would like to thank, above all, my colleagues George Keyes and Joseph Rishel, co-curators of the exhibition *Van Gogh: Face to Face,* for their support of this project, together with Deanna M. Griffin, Alexandra Ames Lawrence, and Kathleen McDonald, who have helped in the preparation of this book. The publication *Van Gogh: Face to Face* (Detroit and London: The Detroit Institute of Arts, in conjunction with Thames and Hudson, 2000) was coordinated by Julia Henshaw; I owe a debt of thanks to her and to our co-authors Roland Dorn, Lauren Soth, and Judy Sund.

The frequent quotations of van Gogh's letters in my text are indexed to *The Complete Letters of Vincent van Gogh,* edited by Vincent W. van Gogh (Greenwich, Conn.: New York Graphic Society, 1958), or to *The Letters of Vincent van Gogh,* edited by Ronald de Leeuw (London and New York: Allen Lane–The Penguin Press, 1996); the letters quoted here are written to Theo van Gogh, except for those prefixed by the letter *W,* which were sent to Vincent's sister Wil. John Rewald's *Post-Impressionism from van Gogh to Gauguin* (New York: The Museum of Modern Art, rev. ed., 1978) is the classic study of van Gogh's development for the general reader; the catalogues by Jacob-Baart de la Faille (*The Works of Vincent*

Van Gogh: His Paintings and Drawings, Amsterdam: Meulenhoff International, 1970) and Jan Hulsker (*The New Complete Van Gogh: Paintings, Drawings, Sketches,* Amsterdam: J. M. Meulenhoff, 1996) provide analysis as well as comprehensive listings of paintings and drawings by the artist. Their catalogues are cited in the index as F. and JH.

Three exhibition catalogues are important sources of information on the artist: Bogomila Welsh-Ovcharov's *Van Gogh à Paris* (Musée d'Orsay, Paris: Editions de la Réunion des musées nationaux, 1988), and two others by Ronald Pickvance (*Van Gogh in Arles,* New York: The Metropolitan Museum of Art: H. N. Abrams, 1984; and *Van Gogh in Saint-Rémy and Auvers,* New York: The Metropolitan Museum of Art: H. N. Abrams, 1986) are the most comprehensive studies of the last five years of the painter's life. Finally, Susan Alyson Stein's compendium, *Van Gogh: A Retrospective* (New York: Hugh Lauter Levin Associates, 1986) provides an overview of writings by and about the artist. Drawing on these and other resources, van Gogh enthusiast David Brooks has created the Van Gogh Information Gallery, a useful website devoted to the artist, at www.vangoghgallery.com.

—GEORGE T. M. SHACKELFORD

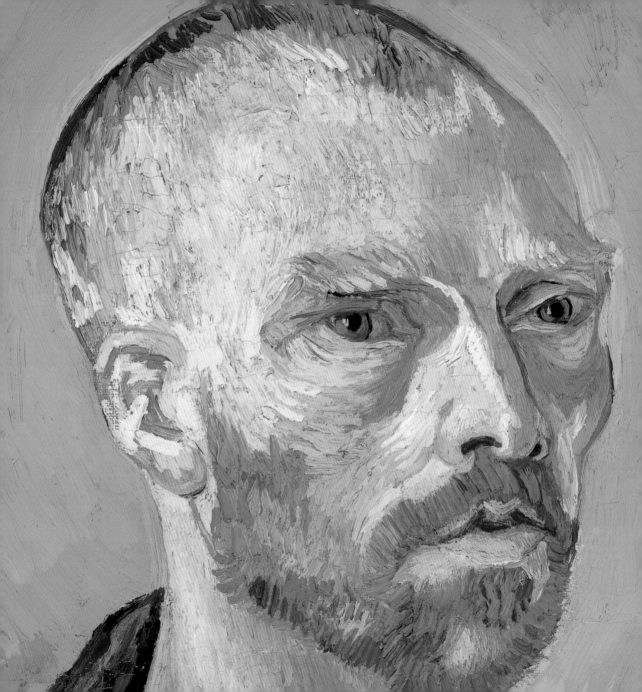

IN THE MORE THAN ONE HUNDRED YEARS since his death in 1890, Vincent van Gogh has become one of the most celebrated painters in the history of art. His work was known only to a close circle of admirers at the time of his suicide, and yet today such a painting as his *Starry Night* or one of his still lifes of sunflowers is recognized immediately, as is almost any image or caricature of the artist himself. Vincent has become, indeed, one of the most romanticized figures in history, the subject of art-world scandal, sensational journalism, and award-winning motion pictures, as well as a virtually unceasing flow of scholarly and popular literature. This book will take another point of view, inviting the reader to study only one aspect of the painter's glorious, if all too brief, career: his activity as a portraitist. From his modest Dutch beginnings to the splendid last works he painted in France, van Gogh looked upon the portrait, again and again, as a means of expressing his abiding interest in his fellow man. This narrative will attempt to bring the reader face-to-face with these men and women, and with the artist himself.

Opposite: *Self-Portrait Dedicated to Paul Gauguin* (detail), 1888.

VINCENT VAN GOGH was the eldest surviving child of Theodorus van Gogh, a Protestant minister, and his wife, Anna Cornelia Carbentus. Born in 1853, Vincent was the second son to bear that name: a boy had been stillborn a year earlier. The future painter was followed by a sister, Anna, born in 1855, a brother, Theo, born in 1857, and by two more sisters, Lies and Willemien, called "Wil," and another brother, "Cor," the last born when Vincent was fourteen years old. At the time of Vincent's birth, Theodorus held a church in Brabant, in the southern Netherlands, ministering to the rural peasantry, but the clergyman's three brothers were active in the art business. On the recommendation of Vincent's uncle "Cent," the sixteen-year-old boy was apprenticed to The Hague branch of the Paris-based Goupil & Cie., an international firm that dealt in original paintings but specialized in the publication and sale of luxury reproductions.

From 1869 until 1876, Vincent worked for Goupil, first in The Hague, then from 1873 in London—and from there back and forth to Paris, briefly in 1874 and then again for nearly a year beginning in the spring of 1875. He was exposed, in the Goupil galleries, to a wide assortment of works of art, from the modern French, English, and Dutch schools, and he came to know something of the business of picture-selling from his employers. But he also took refuge in the public galleries and museums in London and in Paris, studying paintings there and showing a particular interest in portraiture and other forms of figure painting. "How I should

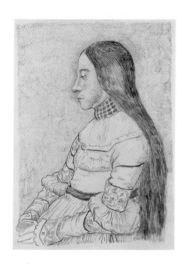

1. Daughter of Jacob Meyer, after Holbein, 1881

like to have you here," he wrote from Paris to Theo, who had gone to work for Goupil in Brussels, "to show you the Luxembourg and the Louvre, &c., but I have the feeling that you, too, will be coming here one day." [LETTER 43]

Indeed, Theo was eventually to direct a Parisian branch of the firm that succeeded Goupil, but Vincent's fortunes in the company were not so happy: the collapse of his relationship with Goupil came in the early spring of 1876, and from that date until he definitively took up the study of art in 1880, he drifted from one job to another, seemingly never quite sure of what might best suit his temperament. His ambition, however, was to work for the good of his fellow man: at first he taught at an English boy's school, then became an assistant preacher for a fervent half a year. He returned to the Netherlands to work in a bookshop, then took up the formal study of theology, abandoning that, in turn, to become an evangelist among coal miners. Finally, in 1879, he returned to art. He obtained paints and drawing materials, and set about making studies of the people to whom he ministered: "Have drawn yet another portrait since [you left]," he wrote to his brother Theo in August. [LETTER 132]

A year later, in September 1880, he was hard at work teaching himself to draw. "I work regularly on the 'Cours de Dessin Bargue,'" he wrote, referring to a drawing manual published by Goupil, "and intend to finish it before I undertake anything else, for day by day it makes my hand as well as my mind more supple and strong." [LETTER 136] Among the drawings van Gogh copied were several portraits; indeed, one of the earliest of the artist's surviving drawings is the portrait he copied from a page in this manual, a study after a drawing by the Renaissance painter Hans Holbein (fig. 1). Vincent, working in his parents' house in the Dutch town of Etten, had begun to experiment with drawing from live

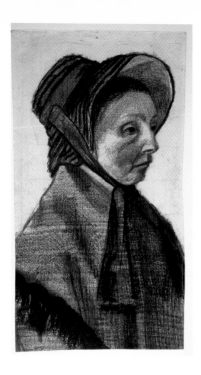
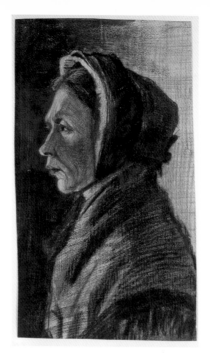

models, but in this sheet, he transcribed, in delicate strokes of pencil and pen, the refined and incisive contours of Holbein's original. Some years later, Vincent would talk of his admiration for art that seized "a figure from the center, not from the contours." [LETTER 447] It was in this direction that he took his style in the remarkable studies he made over the course of 1882 and 1883 in The Hague, where he returned to obtain experience in art that he could not get at home.

The drawings made by van Gogh during his time in The Hague are some of the most beautiful and powerful of his career. Over the course of his stay in the city, he produced some three hundred studies of landscape and figures, among them his first true investigations of a range of portrait

2. *Woman Wearing a Dark Bonnet*, 1883

3. *Head of a Woman in a Dark Bonnet*, 1882

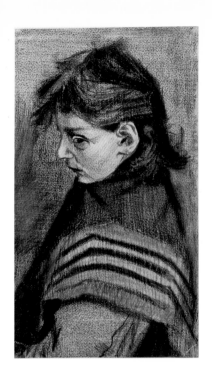

4. Head of a Girl Wearing a Shawl, 1883

types. These drawings, somber in tonality, even brooding, must be seen against the background of van Gogh's desire "to do drawings which touch . . . people. In either portraiture or landscape I should wish to express, not sentimental melancholy, but serious sorrow." "In short," he wrote to his brother, "I want to progress so far that people will say of my work, 'he feels deeply, he feels tenderly'—notwithstanding my so-called roughness, perhaps even because of it." [LETTER 218] And it is at this time, too, that Vincent was to meet and befriend—and eventually to shelter—a woman, Sien Hoornik, a pregnant prostitute. Against the objections of his family and the established artists in The Hague, Vincent grew closer to Sien.

The woman, together with her young daughter and her mother, became Vincent's models for a remarkable series of bust-length studies in pencil and chalk, seized this time not as contours but "from the center." Against light or dark backgrounds, the two women belie their downcast state as they pose in the dark dresses, shawls, caps, or bonnets that they brought with them and that the artist particularly appreciated (figs. 2, 3). The daughter was drawn, urchinlike, in a striped shawl, recalling the black-and-white illustrations in English popular novels that van Gogh collected and prized at this time (fig. 4).

In the hope of making drawings like the "heads of the people" popular in the English illustrated press, Vincent found among the poorest people in The Hague models that he could afford to pay. The pensioners at a home for old men yielded a particularly eccentric model who posed repeatedly for the artist in 1882 and 1883. He was, on the evidence of a full-length drawing, a somewhat gaunt and angular figure (fig. 5). In three great head studies of this old man, with his craggy cheeks, toothless mouth, and long, beaklike nose, van Gogh explores the effects of varying light and pose as well as a variety of professional guises. In one drawing (fig. 7) he is posed against a

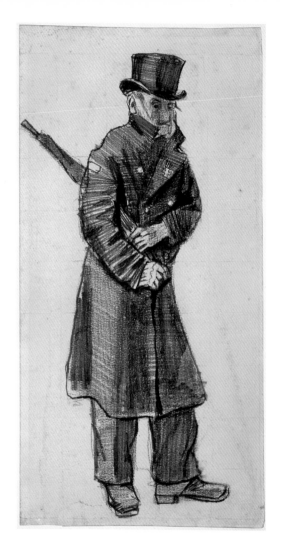

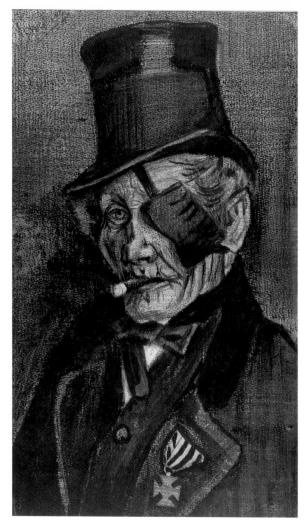

5. *Pensioner, Veteran with an Umbrella under his Arm,* 1882

6. *The Wounded Veteran,* 1882

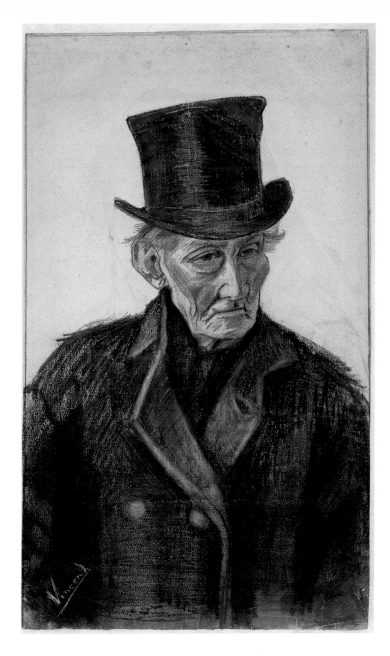

7. Old Man in a Top Hat, Bust, 1882

light background, in a heavy topcoat and black silk hat; in another, now called *The Wounded Veteran,* the same model dons an eye patch and a medal to indicate his profession. And in a third, the model affects the garb of a fisherman—a persona that Vincent wanted to study in the original. In default of an actual fisherman, a fisherman's hat would do: "Tomorrow I get a sou'wester for the heads," he wrote. "Heads of fishermen, old and young, that's what I have been thinking of for a long time, and I have made one already, then afterward I couldn't get a sou'wester. Now I shall have one of my own, an old one over which many storms and seas have passed." [LETTER 261]

In the course of studying how to convey fervent feeling and psychological truth through these likenesses, Vincent, then, refrained from depicting the individual psychology of his sitters, preferring to cast them in roles of his own choosing. But even if neither the drawings of Sien and her family nor the studies of the pensioners can be seen as portraits in the conventional sense, they are character studies—essays in likeness and expression—that contributed greatly to van Gogh's growth as a portraitist.

They also paved the way for the studies he made in preparation for his first masterpiece, which he undertook after his move to Nuenen, where his parents now lived, at the end of 1883. Inspired by what he had read about the French nineteenth-century master Jean-François Millet, van Gogh was determined to become a painter of peasant subjects. He continued to make portrait studies of peasant farmers around him, "working very hard on the series of heads from the people which I have set myself to make . . . in the evening I generally sketch them from memory on a little scrap of paper. . . . Perhaps later I will make them in watercolor too, but first I must paint them." [LETTER 390] He studied the men and women at their labors in the

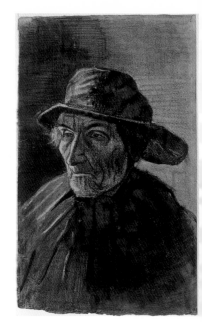

8. *Head of a Beardless Fisherman with Sou'wester,* 1883

14.

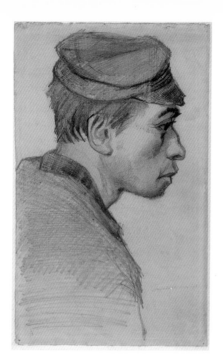 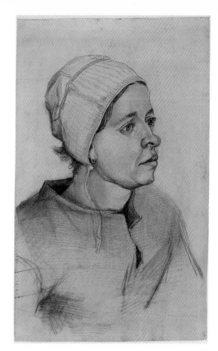

9. *Head of a Young Peasant with Cap*, 1885

10. *Head of a Peasant Woman with White Cap*, 1885

fields, or weavers at their looms, but his imagination came back again and again to their faces. "I don't yet know what I shall do with those heads," he confessed to Theo, "but I want to extract the motif from the characters themselves. But I know quite well why I made them, and what in general I have in mind." [LETTER 391]

The portrait studies range in medium and in finish. The drawings in black chalk or pencil on creamy paper (figs. 9, 10, 11) show a refinement and sometimes even an elegance that recalls the models by Holbein that van Gogh had copied a few years earlier. But the painted studies often verge on the grotesque. In them, van Gogh sought out and exaggerated

the most irregular qualities of each sitter's physiognomy: "I long most of all," he wrote, "to learn how to produce those very inaccuracies, those very aberrations, reworkings, transformations of reality, as may turn it into, well—a lie if you like—but truer than the literal truth." [LETTER 418] He became increasingly concerned with issues of color, and paradoxically his palette darkened. He painted his sitters "with the earth," as had been said of Millet, in colors of gray and brown, barely accented by the primaries of red, yellow, and blue. The culmination of this research was, of course, van Gogh's first masterpiece, *The Potato Eaters* (1885, van Gogh Museum). When he sent the painting to Theo—his brother was by now a figure of growing reputation in the Parisian vanguard—he avowed that he was "not at all anxious for everyone to like it or to admire it at once." [LETTER 404] And if he was all the same discouraged by the coolness with which its brooding tonalities and grossly drawn peasant figures were received in the birthplace of Impressionism, he continued on, making his portrait studies even more vigorously expressive.

Vincent had set his sights on Paris—then the capital of European artistic culture. It was the home of the great Realist and Naturalist writers he so much admired—Emile Zola, above all, but also Edmond de Goncourt; and of course the Paris Salon was the proving ground for painters from every country in Europe. But the artist needed more training, his brother argued, and Paris could wait. Vincent went, instead, to Antwerp, where he hoped to enroll in the academy. During his first weeks in Rubens's native city, he decided that he could expand on his skill at painting portrait studies of peasants, since "what the dealers say is that women's heads or women's figures are most likely to sell." [LETTER 440] Searching for models, he delighted in the city types that he was able to find: "The models here appeal to me because they're so completely

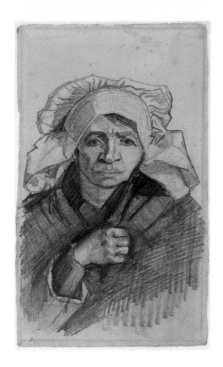
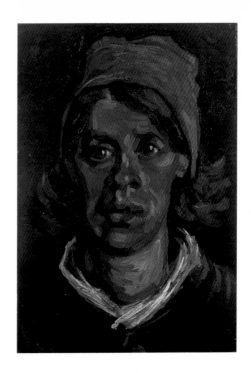

1. Head of a Woman with White Cap, 1885
2. Head of a Peasant Woman with Red Bonnet, 1885
(DETAIL), page 19

unlike the models in the country. And more especially because their character is completely different. . . . For much the same reasons that if I paint peasant women I want them to be peasant women—so I want to get a whore's expression when I paint whores." [LETTER 442]

Van Gogh did, in fact, enroll briefly at the academy, where he produced some drawings from nude models or from plaster statuary, attempting to reconcile his own impulses with the standardized draftsmanship of his instructors. But the most forceful works made during his residence in Antwerp are the head studies that he painted and drew of unidentified sitters—people whom Vincent often paid by giving them

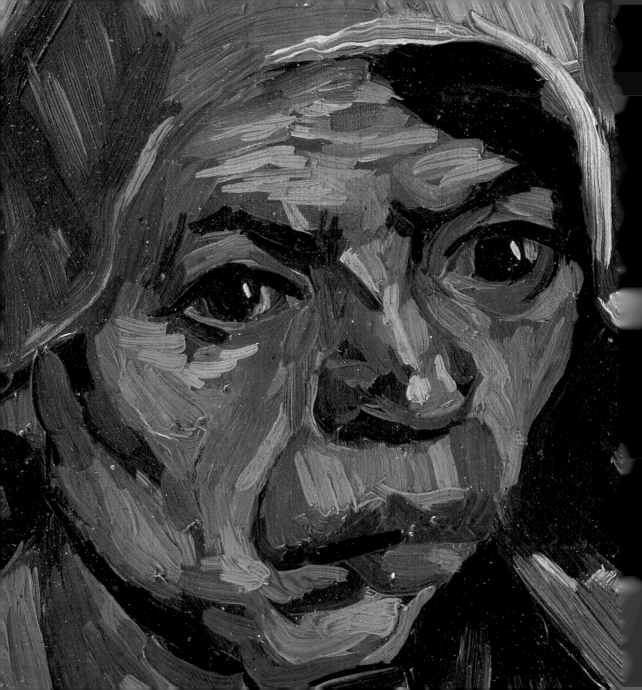

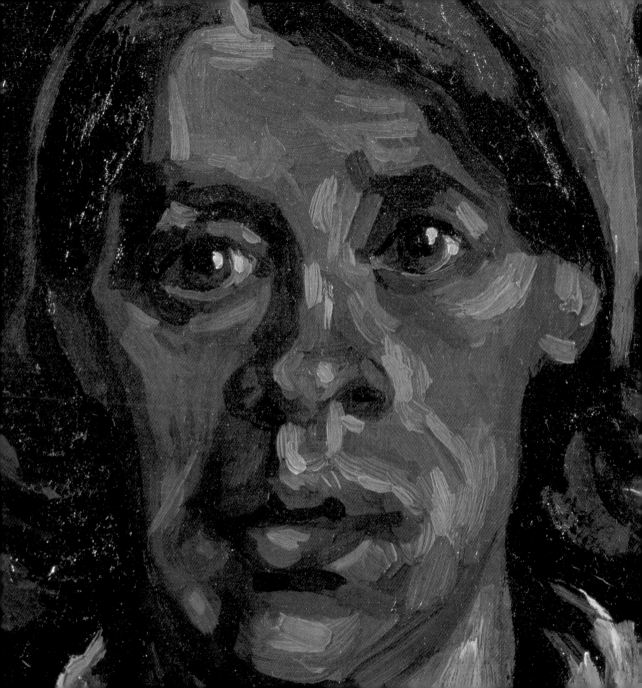

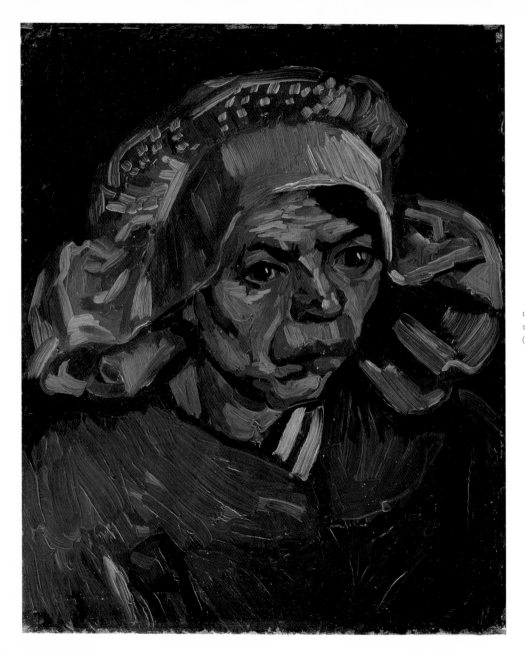

13. *Head of a Peasant Wom[an]*
with White Cap, 1885
(DETAIL), page 18

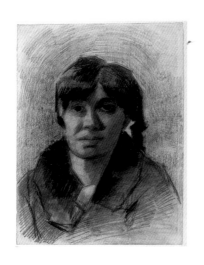

the portrait for which they had posed. One sheet he kept is the extraordinary *Portrait of a Woman* (fig. 14). Here, the artist seems to attempt to penetrate the inscrutable psychology of his sitter through formal means. Her wistful expression is heightened by the dramatic lighting of the face, which in turn is broken into component parts and restructured spatially in a way that prefigures the Cubist experiments of Picasso a generation later. We see here, in other words, Vincent continuing to search for the kind of "transformations of reality" that he hoped would signal a portrait "truer than the literal truth." Disdaining what he considered the mechanical realism of the photograph, van Gogh wrote that "painted portraits have a life of their own, coming straight from the painter's soul, which the machine cannot reach."

His stay in Antwerp was a brief one. Arriving in late November 1885, he was already thinking of moving on to Paris, and on the first of March 1886—taking Theo by surprise—he was there. "Don't be angry with me for arriving out of the blue," he wrote to his brother. They would meet in the afternoon, he hoped, at the Louvre. "Please let me know what time you can get to the Salle Carrée." [LETTER 459]

In one fell swoop, then, van Gogh had entered the world of his younger brother, hoping to find in Paris still more—and better—training in his discipline, as well as opportunities to work and to learn from his contemporaries. He moved in with Theo (who may be the subject of a drawing in chalks that seems to date from this time) (fig. 15), sharing first one, then another apartment in Montmartre, the neighborhood famous for its artistic and bohemian inhabitants and for its galleries of modern art, including the one that Theo directed. Vincent arrived in Paris in time to see the eighth and final exhibition of the Impressionists, dominated by the great series of Edgar Degas's nudes on the one hand,

triumphs of observation, and on the other by the monumental and anti-Impressionist *Sunday Afternoon on the Island of the Grande Jatte* (1886), the latest work by the iconoclastic Georges Seurat.

For some months Vincent contented himself with painting flower studies, along with the occasional cityscape. Gradually he shed the gloomy color schemes of his Netherlandish period and adopted a whole new range of hues, so that by the end of the summer his bouquets glowed with vibrant reds, yellows, and blues. In the autumn, most likely, he took instruction in the studio of the academic painter Fernand Cormon, where he befriended fellow students Henri de Toulouse-Lautrec and Emile Bernard.

At first, he painted few portraits, either because he thought that other motifs were more suitable for the study of color or because he had few obvious models and could not afford to hire professionals. He turned, by degrees, to his own likeness and in the months between autumn 1886 and spring 1888 eventually painted some two dozen self-portraits. The earlier of these, in tones of deep mahogany and ivory, seem to have been inspired by Rembrandt's shadowy self-portraits in the Louvre. But by the time he painted the *Self-Portrait with a Gray Felt Hat* (1886–87) (fig. 17), Vincent had fully come to terms with the Impressionist manner that he had admired in the paintings of Degas, Claude Monet, and Camille Pissarro. This portrait, and two quite like it (figs. 16, 18), reveals van Gogh experimenting with formal modes of self-presentation: in all three, he wears a dark reddish suit with gray-blue trim, but in one he sports a blue silk cravat and a stylish hat; he varies the pose from frontal to facing right to facing left; and he varies the finish—from an Impressionist "comma stroke" to a nearly pointillist dot. In each portrait, however, the painter is the urbane, well-dressed equal to his respected brother, or

16. *Self-Portrait,* 1887

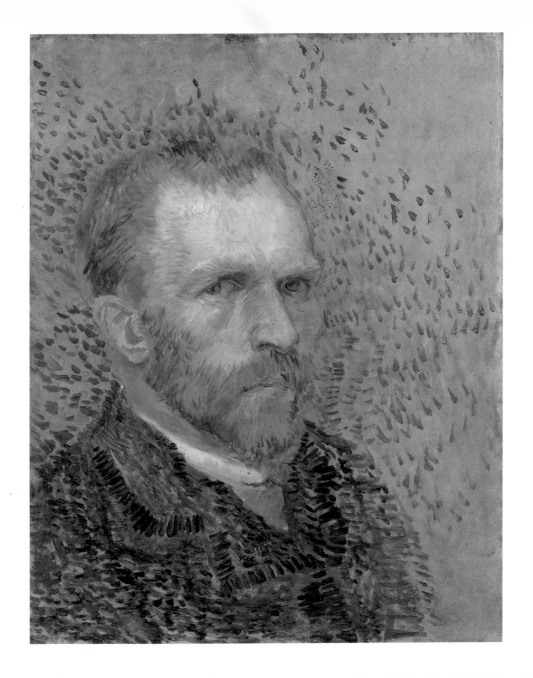

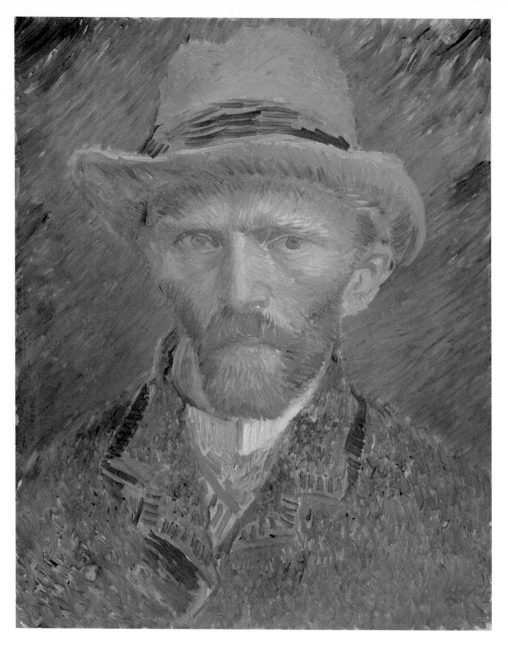

17. Self-Portrait with a Gray Felt Hat, 1886–87

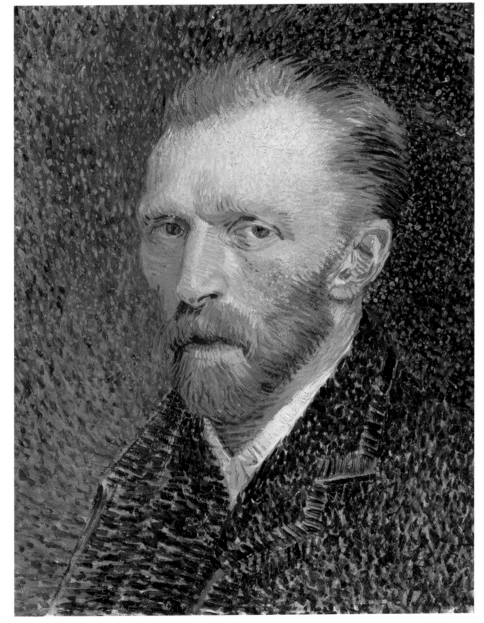

18. *Self-Portrait*, 1887

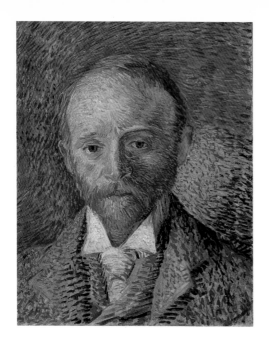
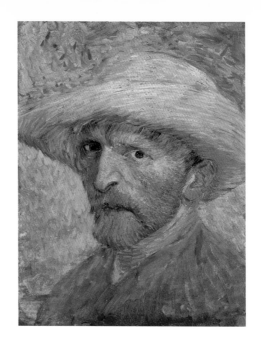

perhaps to his brother's associate Alexander Reid, whom Vincent painted at the same time (fig. 19). In another self-portrait, from 1887 or early 1888, the artist shows himself in more informal terms, wearing a blue smock and a straw hat—to protect his skin from the sun when he worked in the open air (fig. 20).

Among the last of Vincent's Paris self-portraits is one that is among the most striking the artist ever painted (fig. 21), in part because of the unusually penetrating glare of the eyes, which seems to echo the empty but resonant stare of the skull he painted at about the same time (fig. 22). From these eyes, a pattern of light appears to emanate, creating a ring of vibrating brushstrokes around the painter's head. Light and its partner color are, of course, the unruly elements that the painter is seeking to

19. *Portrait of Alexander Reid*, 1887

20. *Self-Portrait with a Straw Hat*, 1887

21. *Self-Portrait with Grey Felt Hat*, 1887–88

(DETAIL), page 29

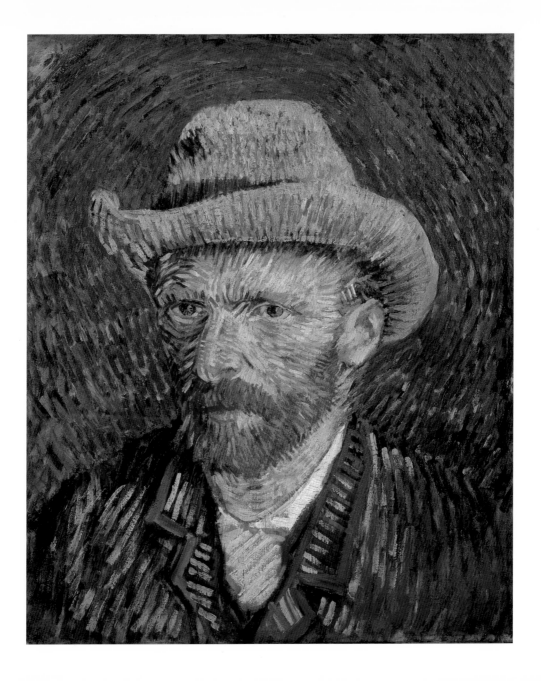

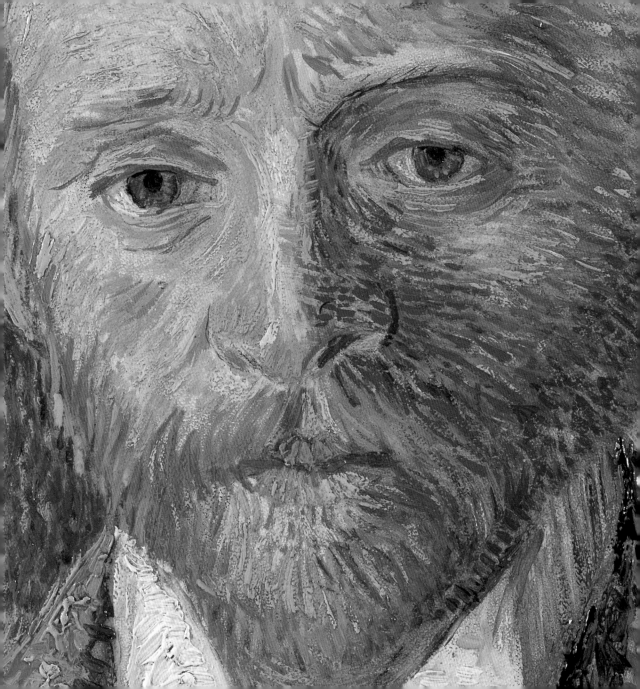

master in such an image, but his goal, once more, is not the re-creation of an observed reality. Instead, he was beginning to harness color to his brushstroke in order to achieve a level of truth in portraiture that went beyond appearance: a few months later, in fact, he was to write that he wanted "to paint men and women with that something of the eternal which the halo used to symbolize and which we seek to convey by the actual radiance and vibration of our coloring." [LETTER 531]

In parallel with his self-portrait series, van Gogh painted a wide variety of sitters connected in one way or another with his newfound circle of friends. Léonie-Rose Davy-Charbuy, the niece of the picture dealer Pierre-Firmin Martin, is the *Woman Sitting by a Cradle* (1887), painted as a compromise between the compositional ideas of Toulouse-Lautrec and the pointillist brushstroke of Seurat or Vincent's friend Paul Signac (fig. 23). In the *Portrait of Père Tanguy* (1887–88) (fig. 24), van Gogh created an unforgettable image of the well-known dealer of paintings and artists' supplies, in whose shop Vincent met Tanguy's friend Paul Cézanne. It is recorded that Cézanne told van Gogh that he painted "like a madman," and in this work the repeated application of thick skeins of brushstrokes contribute to the image's deliberate rejection of naturalist convention. The portrait of Tanguy also pays homage to one of Vincent's allied passions— Japanese art, specifically the color woodblock prints that he had begun to collect some years before and that he was now promoting and acquiring with a portion of what meager income he had. Finally, the portrait confirms the remarkable shift that had taken place in little more than two years—from the murky, light-starved studies of Nuenen peasants to the pulsing patterns of brushstrokes in this icon of the Parisian avant-garde.

Vincent's passion for Japan—and his need to seek a simpler life, far from the temptations of bohemian Paris—led him to his decision to

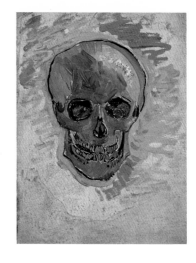

22. *A Skull*, 1887–88

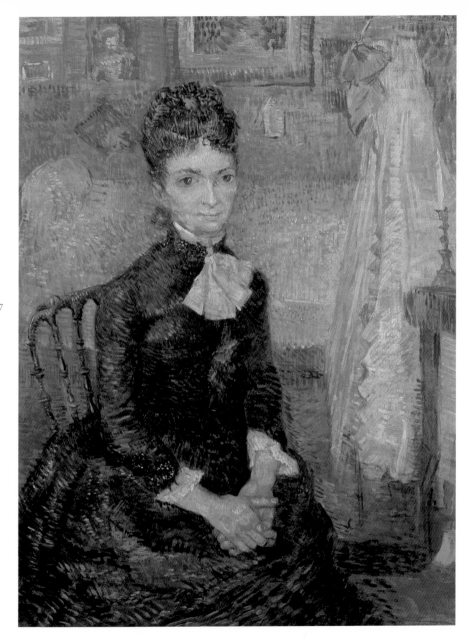

23. Woman Sitting by a Cradle, 1887

journey to the south, to Arles, an ancient town in the heart of Provence. In Provence, oddly enough, he thought he might find the simple lifestyle that he imagined in Japan and that he might found a "studio of the South" where like-minded artists, including his friends Paul Gauguin and Bernard, could paint together, sharing ideas as well as lodging, food, and even supplies. Six months after his arrival in Arles, he painted a self-portrait to send to Gauguin, then living in Brittany, comparing his image—with its short hair and beard—to the portrait of a bonze, or Japanese monk (fig. 25).

But above all, he appreciated the sunlight of Provence, the colors of the landscape, and its inhabitants. He arrived in February to find the almond trees in blossom above an unexpected blanket of snow. For the next several months, however, he reveled in nature as it unfolded in southern France. "I think it exquisitely beautiful here in summer," he wrote to his sister Wil at the end of July. "The green is very deep and rich; the air is thin and astonishingly clear. . . . But what pleases me very much is the gaily coloured clothes, the women and girls dressed in cheap simple material, but with green, red and pink, Havana-yellow, violet or blue stripes, or dots of the same colours. White scarfs; red, green and yellow parasols. A vigorous sun, like sulphur, shining on it all . . ." [LETTER W.5] The colorful costumes to which Vincent refers in his letter and the heat of the summer sun can almost be felt in the intense yellow background of the *Italian Girl* or on the sunburned cheeks of *The Zouave*, portraits Vincent drew and painted during the course of the summer (figs. 26, 27, 28).

In the same letter, the painter announced to Wil that he was at work on "a portrait of a postman in his dark blue uniform with yellow. A head somewhat like Socrates, hardly any nose at all, a high forehead, bald crown,

24. Portrait of Père Tanguy, 1887–88

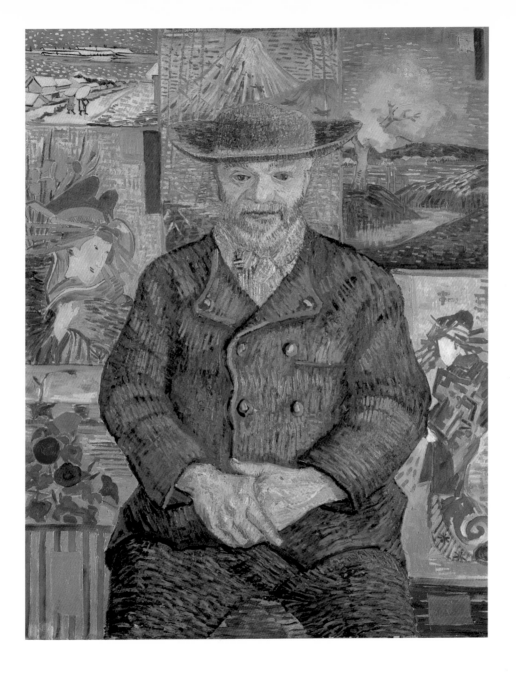

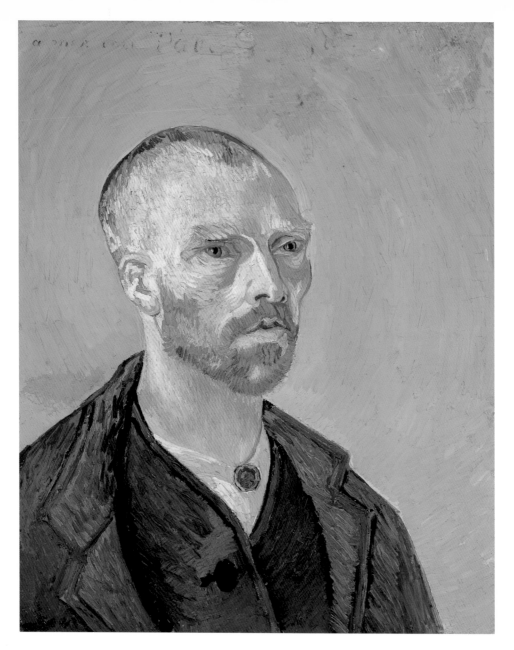

25. *Self-Portrait Dedicated to Paul Gauguin*, 1888

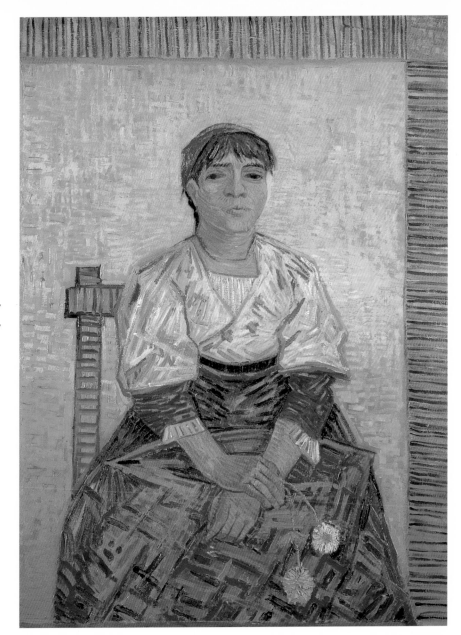

26. *Italian Girl,* 1887
(DETAIL), page 37

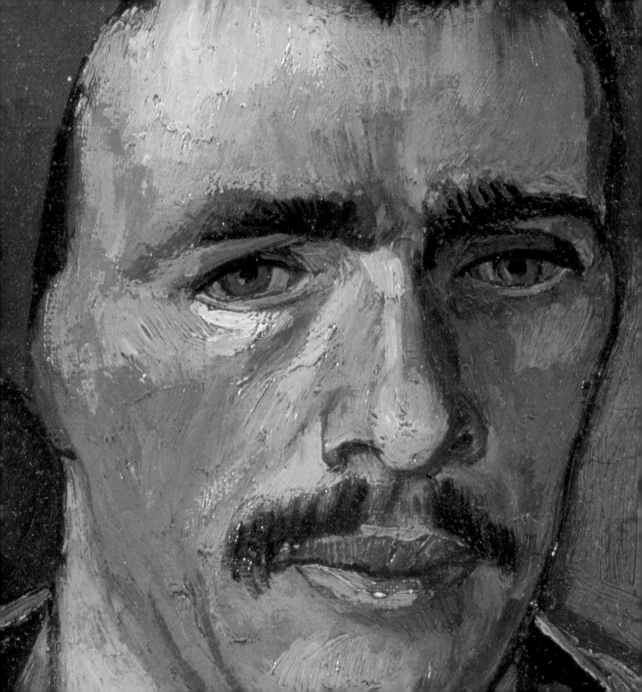

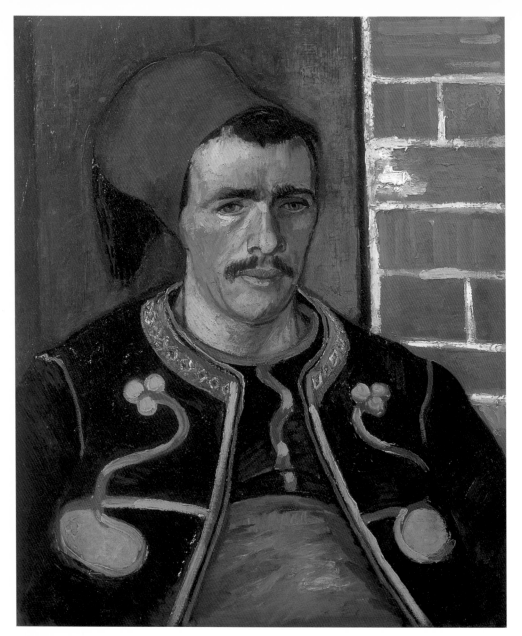

27. *The Zouave*, 1888
(DETAIL), page 36

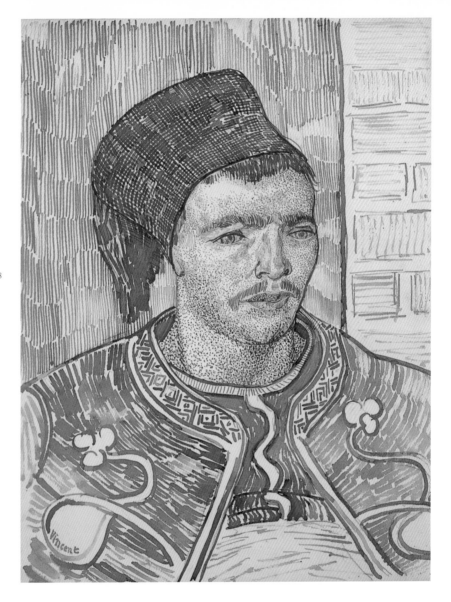

28. *The Zouave (Bust)*, 1888

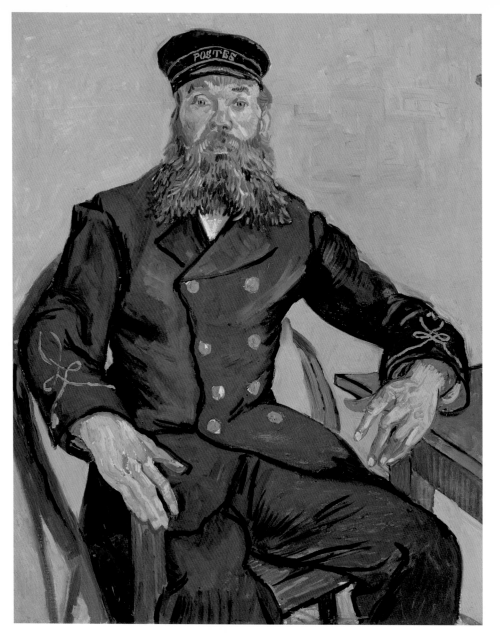

29. *Postman Joseph Roulin*, 188

little gray eyes, bright red chubby cheeks, a big pepper-and-salt beard, large ears." He referred to *Postman Joseph Roulin* (1888), the first of many portraits of his friend, who ran the mail service at the railway station in Arles and who often came to drink at the nearby café, where Vincent rented a room (fig. 29). In addition to the three-quarters-length portrait, van Gogh painted a bust-length version, of which he made a copy in ink (figs. 30, 31). In early December, Vincent wrote to Theo that he had "made portraits *of a whole family,* that of the postman whose head I had done previously—the man, his wife, the baby, the little boy, and the son of sixteen, all characters and all very French. . . . I hope to get on with this and to be able to get more careful posing, paid for by portraits. And if I manage to do the whole family better still, at least I shall have done something to my liking and something individual." [LETTER 560]

Indeed, van Gogh painted the "whole family" in multiple examples—searching, perhaps, to do it "better still." In addition to the strikingly

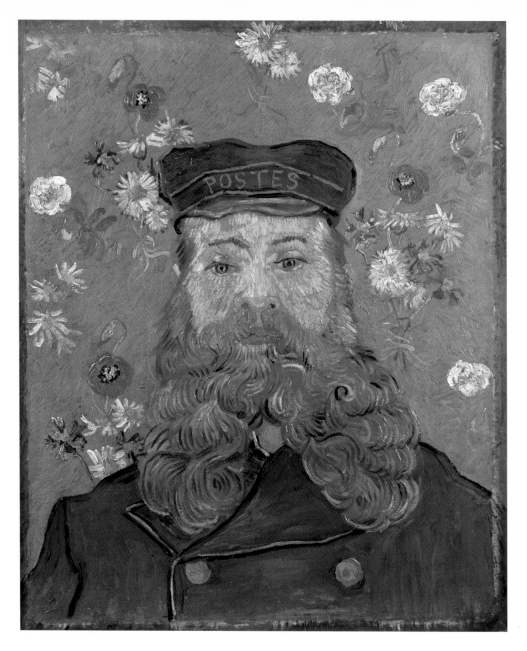

32. *The Postman Roulin*, 1889 (DETAIL), page 46

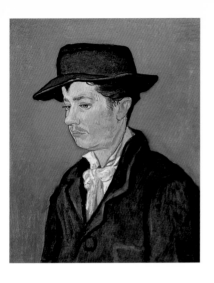

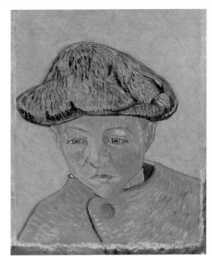

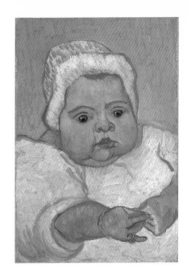

33. *Armand Roulin, Turned to Left,* 1888

34. *Portrait of Camille Roulin,* 1888 OR 1889

35. *Portrait of the Baby Marcelle Roulin,* 1888

simplified portrait of Roulin against a bright yellow background, and another against flowered wallpaper (fig. 32), there are the portraits of his sons Armand (fig. 33) and Camille (fig. 34), and of his infant daughter Marcelle, shown alone (fig. 35), and in the arms of her mother, Augustine Roulin (fig. 36). The paintings made in the summer and autumn, the series of paintings under way in early December, and those that followed are marked by their reliance on contrasts between warm reds and yellows and cooler blues and greens, revealing van Gogh's continuing interest in applying theories of complementary color to his paintings, linked, however tangentially, to their subject matter.

Thus, Patience Escalier, a shepherd, (fig. 37) was painted as if "in the furnace of the height of harvesttime, as surrounded by the whole Midi. Hence the orange colors flashing like lightning, vivid as red-hot iron, and hence the luminous tones of old gold in the shadows." [LETTER 520] And

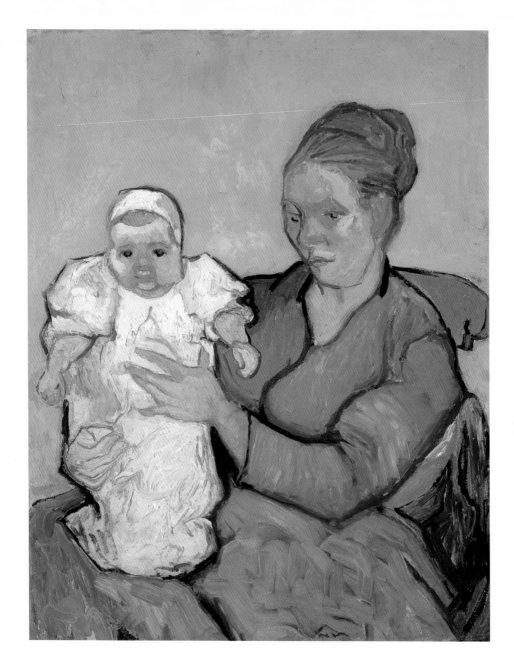

*36. Madame Roulin
and her Baby,* 1888–89

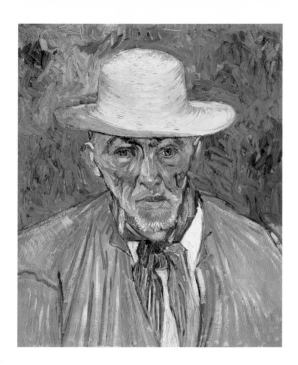 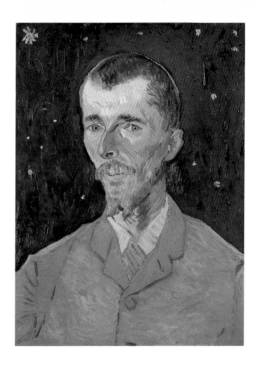

37. *Portrait of a Peasant
(Patience Escalier),* 1888
(DETAIL), page 47

38. *Portrait of Eugène Boch,
"The Poet,"* 1888

Vincent cast his friend the painter Eugène Boch in the role of a poet, (fig. 38) and to finish the painting he became "an arbitrary colorist. I exaggerate the fairness of the hair, I even get to orange tones, chromes and pale citron yellow. Behind the head, instead of painting the ordinary wall of the mean room, I paint infinity, a plain background of the richest, intensest blue that I can contrive and by the simple combination of the bright head against the rich blue background, I get a mysterious effect, like a star in the depths of an azure sky." [LETTER 520]

Vincent's descriptions of his working methods reveal his understanding of the laws of color and his desire to apply these laws in such a way as

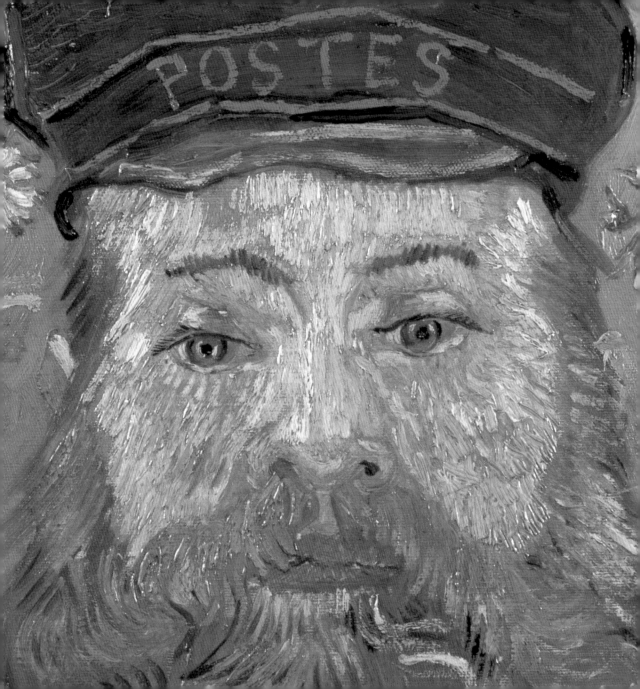

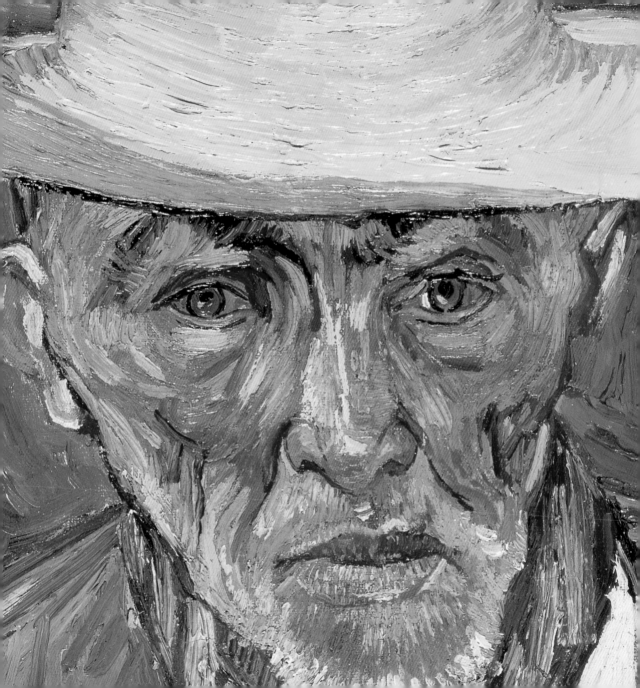

to make portraits more meaningful. As an artist van Gogh was essentially self-taught, but through his reading and study he had come to know the color theories of Eugène Delacroix and the more recent writings on color by men of science. Although to the townspeople of Arles Vincent appeared rough and unschooled, he was a profoundly learned man—he spoke and wrote not only in Dutch but in French, English, and German and was an avid reader of history and fiction. With companions like Boch, and with Gauguin, who came, at last, to Arles in late October 1888, Vincent could discuss the theoretical side of art, the reasons for his careful choice of colors that may, to uninformed eyes, have seemed inappropriate or simply capricious.

Vincent commemorated his friendship with Gauguin by painting a symbolic pair of portraits of the two. *Van Gogh's Chair* (fig. 54, page 72) stands for the painter himself, the rush seat of the rough-hewn wooden chair holding his pipe and tobacco. In the week before Christmas of 1888, the friendship between van Gogh and Gauguin began to unravel, and on the morning of December 24, after a quarrel the night before, Gauguin returned to their lodgings to find that van Gogh had mutilated the lower portion of his left ear. At the hospital in Arles, Vincent was treated by Dr. Félix Rey, who became a friend to the artist. After two weeks, he returned to his house (Gauguin had returned to Paris) and showed his recent paintings to the doctor. In the weeks that followed, he not only painted a portrait of Dr. Rey but began work on two self-portraits depicting his bandaged ear (fig. 39). He resumed work at this time on a painting he had begun in the days before his accident, a portrait of Mme. Roulin seated against a wallpaper background, "which of course I have calculated in conformity with the rest of the colors." [LETTER 571a] He wrote to Gauguin about the painting, claiming that the arrangement of

39. *Self-Portrait with Bandaged Ear,* 1889

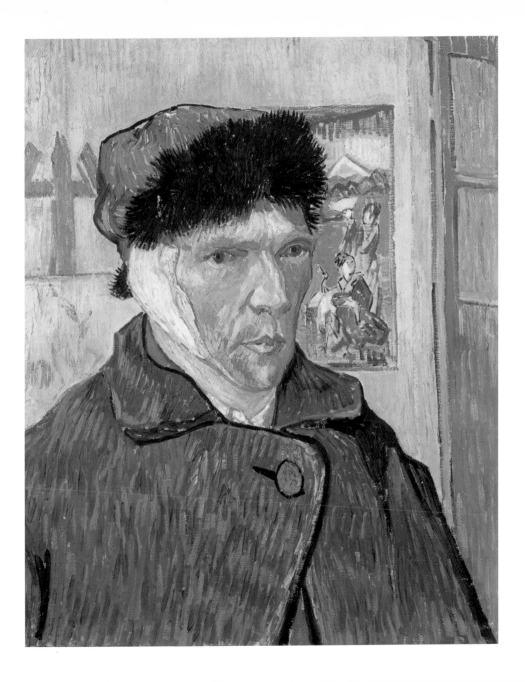

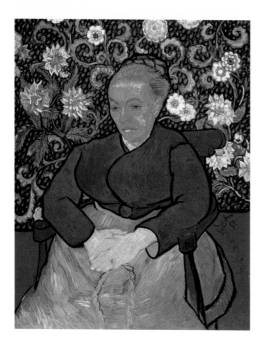

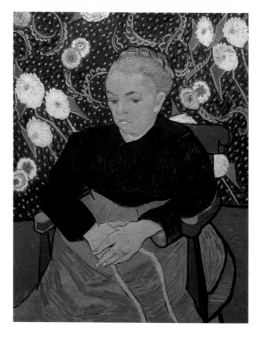

red, yellow, and green hues he had devised was as good as anything he had ever done. He inscribed the portrait "La Berceuse," meaning both "lullaby" and "she who rocks the cradle," and envisioned flanking the painting with two of his still-life compositions of sunflowers, creating a modern triptych imbued with joy and the affirmation of life. He painted, in all, five versions of the original composition, each varying slightly in the arrangement and balance of the complementary colors of red and green (figs. 40, 41, 42).

Vincent gave one of the versions of *La Berceuse* to Madame Roulin. Her feelings about the painting are not recorded, though it is said that Dr. Rey's mother so hated the portrait van Gogh painted of her son that

40. *'La Berceuse' (Madame Roulin), 1888–89*

41. *Madame Roulin Rocking the Cradle (La Berceuse), 1889*

42 *La Berceuse (Madame Roulin), 1889*

(DETAIL), page 52

50.

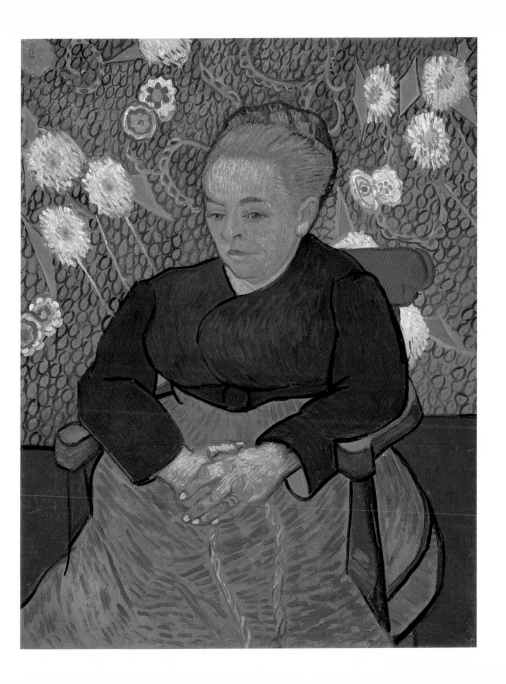

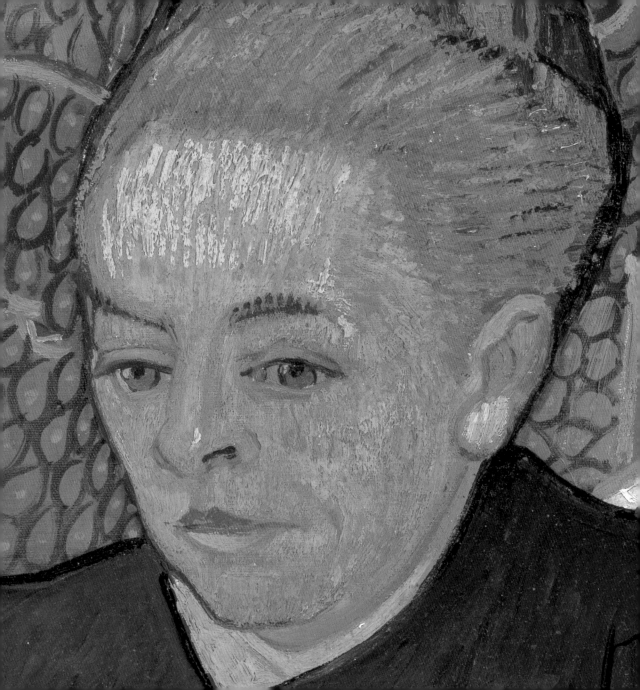

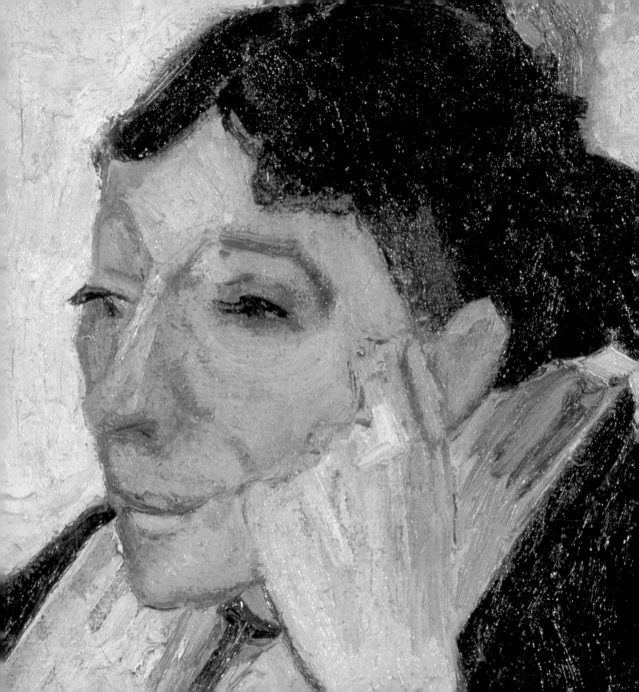

she used it to cover a hole in a chicken coop. These portraits, with their intense, unnatural coloring, must, in fact, have seemed strange, perhaps even monstrous, to the people of Arles in 1889. Although van Gogh cast the wife of the owner of the Café de la Gare in the role of an urbane sophisticate—in juxtaposition to Madame Roulin, an emblem of mother-hood—it must be assumed that Madame Ginoux (fig. 43)and her fellow Arlésiens would have seen the portraits, actually the result of Vincent's exacting calculations, as the product of an unbalanced mind. And in the weeks that followed, when the painter was beset by hallucinations, fits of fainting, and paranoia, they believed themselves to be right in their judg-ment. At the end of April, Vincent agreed to seek refuge at the asylum in nearby St.-Rémy, and moved there in early May.

In the first months of his residence in St.-Rémy—from May to July 1889—he painted only landscapes, at first in the garden of the asylum and then in the countryside around the town. In mid-July, in the process of painting a landscape of a field, he experienced a seizure, an attack that led to a five-week illness. At the end of August he returned to painting but was not willing to leave the grounds of the hospital. He turned to his own image, once more, as subject. "They say—and I am very willing to believe it—that it is difficult to know yourself," he wrote to Theo, "but it isn't easy to paint yourself either. So I am working on two portraits of myself at this moment. . . . One I began the day I got up; I was thin and pale as a ghost. It is a dark violet-blue and the head whitish with yellow hair, so it has a color effect. But since then I have begun another one, three-quarter length on a light background." [LETTER 604] The first of these self-portraits recalls the portrait of Boch, "the poet," in its contrasts of blue-violet and yellow-orange (fig. 44). But the second, (fig. 45) with its powerful brushstrokes that

443. *L'Arlésienne (Madame Ginoux)*, 1888

(DETAIL), page 53

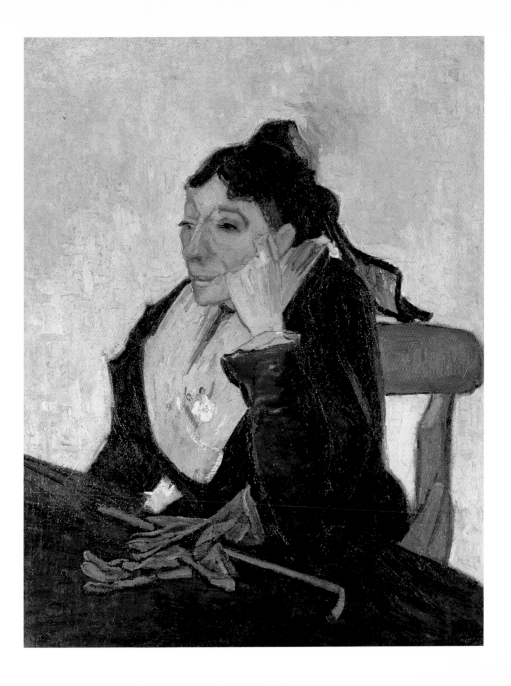

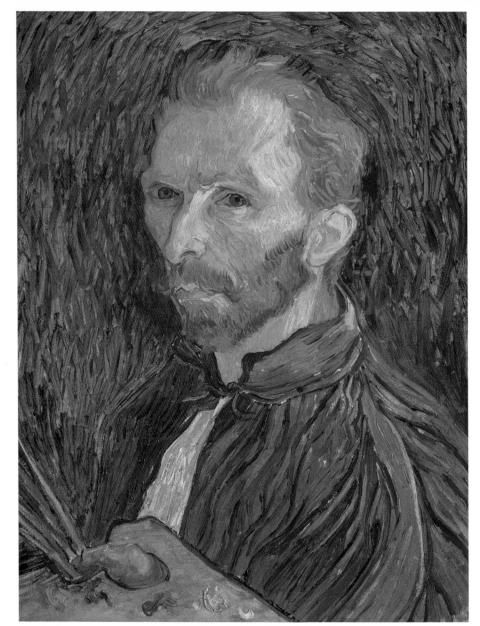

44. *Self-Portrait*, 1889
(DETAIL), page 74

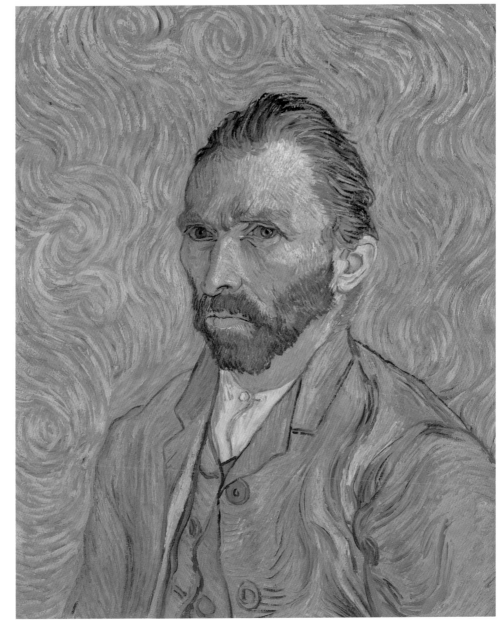

45. *Self–Portrait,* 1889

(DETAIL), page 75

dominate the largely unified color, seems to evoke the *Self-Portrait with Grey Felt Hat* of the previous year—with the new fervor of the celebrated *Starry Night,* painted just weeks before.

The *Portrait of Trabuc* (fig. 46), the head attendant at the asylum, was painted in the first days of September, shortly after the second St.-Rémy self-portrait. Like that work, it depends on linear patterns of brushstroke and the precise draftsmanship of the face for its great success, rather than on effects of contrasting color. Van Gogh recognized that he was searching for a different result than he had pursued in the Arles portraits. He was pursuing an intensity of particular psychological penetration that had not been the aim of his recent work. The portrait of Trabuc, he noted, "makes a rather curious contrast with the portrait I have done of myself, in which the look is vague and veiled, whereas he has something military in his small quick black eyes." [LETTER 605] Still unwilling to leave the grounds of the asylum, he also painted the gardener who worked there, setting the figure against a verdant background (fig. 47).

In December, van Gogh suffered a relapse of his illness, and at the end of February 1890, he had yet another attack, from which he did not recover until April. In consultation with Theo, Vincent decided to move closer to Paris, to Auvers-sur-Oise, and to place himself in the care of Dr. Paul-Ferdinand Gachet, a homeopathic specialist and a friend and collector of many of the Impressionists. He spent a few days in Paris, seeing Theo—himself in ailing health and occasionally depressed—Theo's wife Jo, and their son, his namesake. Paris disturbed him, however, and he left for Auvers, just northeast of the capital, on May 20, 1890.

He wrote to Theo that he found Gachet "as ill and distraught as you or me" but became friendly with him at once, etching a portrait of him

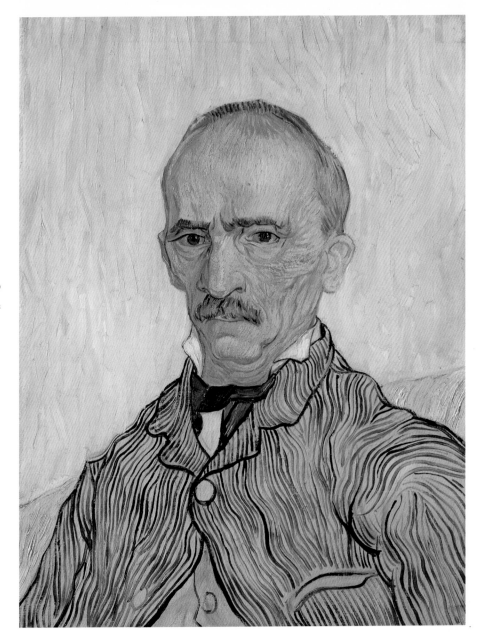

46. *Portrait of Trabuc,* 1889

(DETAIL), page 62

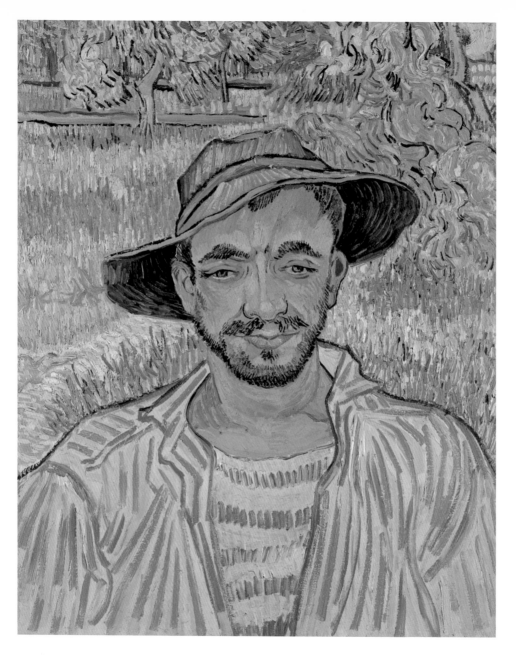

47. *The Peasant (Gardener)*, 1889

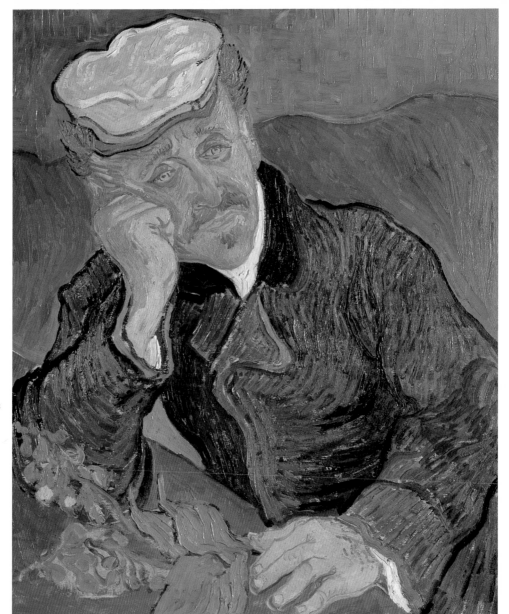

48. *Portrait of
Dr. Gachet*, 1890
(DETAIL), page 63

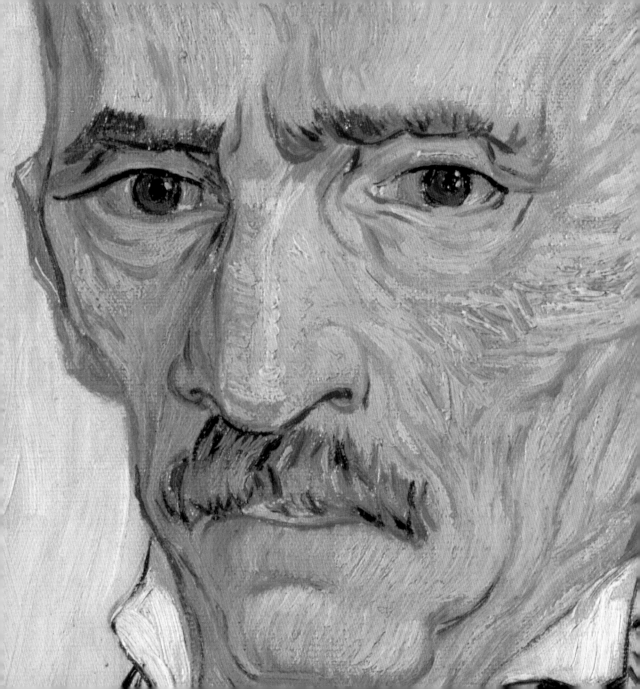

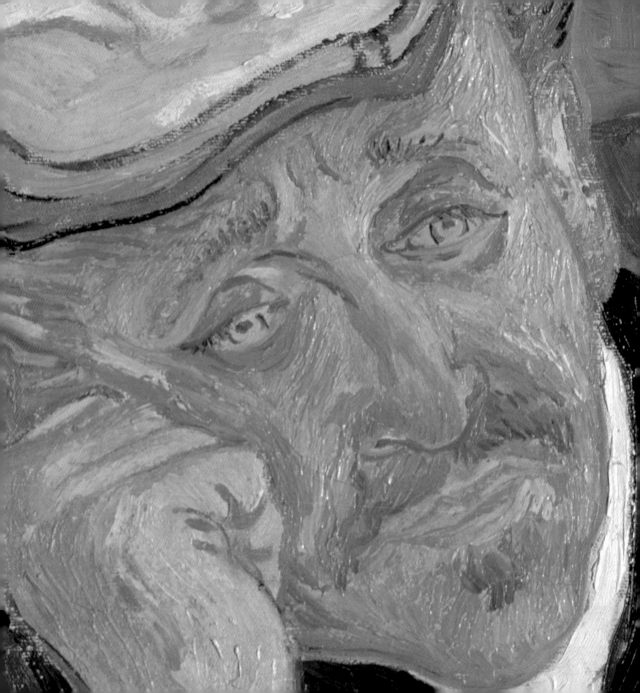

soon after their first meeting. And by the first week in June, he was at work on a painted portrait of the doctor leaning on a table, with a sprig of foxglove in his hand; a second version of the painting (fig. 48) was painted at the end of the week. As he had in the Arles portraits, he used complementary colors as the basis for the image: "Thus, the portrait of Dr. Gachet shows you a face the color of an overheated brick, and scorched by the sun, with reddish hair and a white cap, surrounded by rustic scenery with a background of the hills; his clothes are ultramarine—this brings out the face and makes it paler, notwithstanding the fact that it is brick-colored." [LETTER W22]

In the next month or so, van Gogh produced a dizzying group of portraits, choosing his models from Gachet's household or the young people of Auvers, varying the backgrounds and formats of his compositions, and the facture and finish of his paints. Four canvases measuring roughly 50 cm square were used to produce two pairs of related compositions. His delightful painting of a young girl sitting in a grassy field (fig. 49) was paired with an image of two children against a view of Auvers. In another group, van Gogh showed two young women, Adeline Ravoux and an unidentified girl mistakenly called *The Little Arlésienne*, to the left of the picture space, against vague backgrounds, one flowered, the other dotted (figs. 50, 51). Compositionally so similar, the paintings are nonetheless almost opposites of each other: in the portrait *Adeline Ravoux*, the fair-haired model's face is struck by golden light, against a deep blue background, while in the other portrait, the once vivid pink background plays against the shadowy greens of the dark-haired model's image. The pattern of green dots on the pink background reverses the pattern of pink on green that marks the background of *Marguerite Gachet at the Piano*—the

49. *Levert's Daughter with an Orange*, 1890

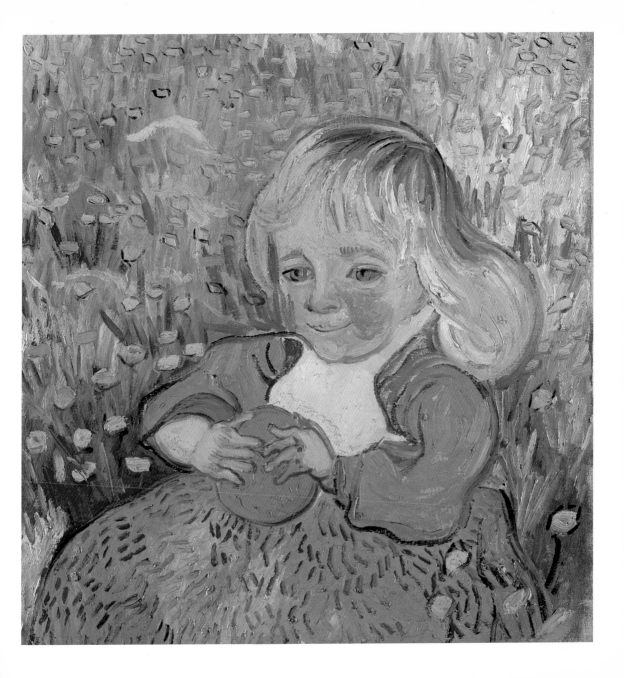

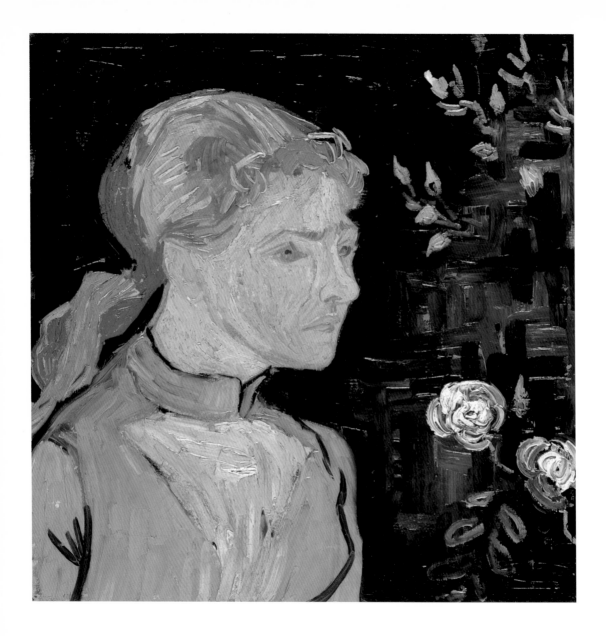

50. *Adeline Ravoux*, 1890

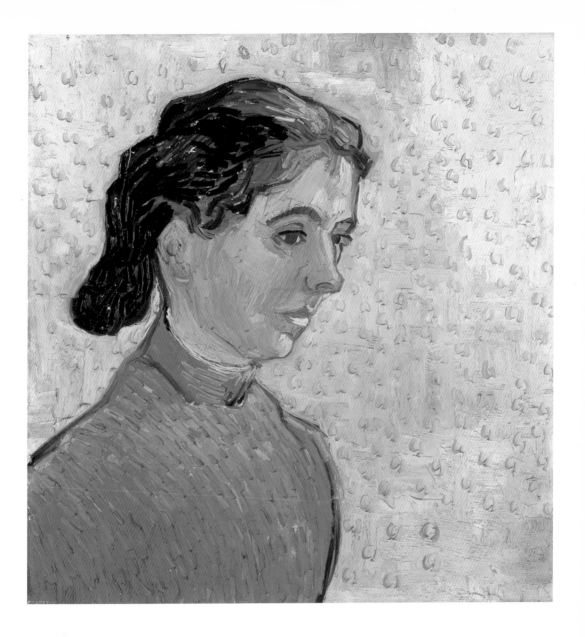

51. *The Little Arlésienne*, 1888

(DETAIL), page 70

portrait of the doctor's daughter (fig. 52). Thinking of the relation-
ships between two compositions, Vincent wrote to Theo that he had
"noticed that this canvas goes very well with another horizontal one
of wheat, as one canvas is vertical and in pink tones, the other pale
green and greenish yellow, the complementary of pink; but we are
still far from the time when people will understand the curious rela-
tion between one fragment of nature and another, which all the same
explain each other and enhance each other. But some certainly feel it,
and that's something." [LETTER 645]

It is tempting to think that the artist painted the *Peasant Woman
Against a Background of Wheat,* (1890) (fig. 53) as a way of making that
"curious relation between one fragment of nature and another" more
easily understood. In these canvases, among the most ambitious the
artist painted, he set up another series of contrasts: one girl is shown
indoors, the other beneath the sun; one girl is active, the other
passive; one girl is from a bourgeois family, the other presumably
resting in the field in which she has been working.

In the last months of his life, then, van Gogh turned again and
again to portraiture as a means of experimenting with form, color, and
meaning. These paintings, although broadly conceived and swiftly
executed, are among the most moving of the artist's portraits. "What
impassions me most—much, much more than all the rest of my
métier—is the portrait, the modern portrait," Vincent wrote to Wil
in early June. He went on to reaffirm his search for novelty in color,
"and surely I am not the only one to seek it in this direction," he
wrote. "I should like—mind you, far be it from me to say that I shall
be able to do it, although this is what I am aiming at—I should like
to paint portraits which would appear after a century to people living

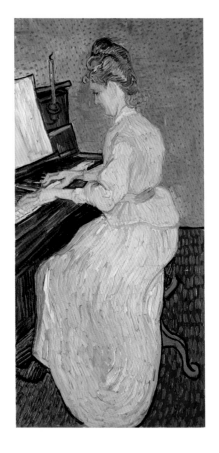

52. *Marguerite Gachet at the Piano,* 1890

53. *Peasant Woman Against a
Background of Wheat,* 1890
(DETAIL), page 71

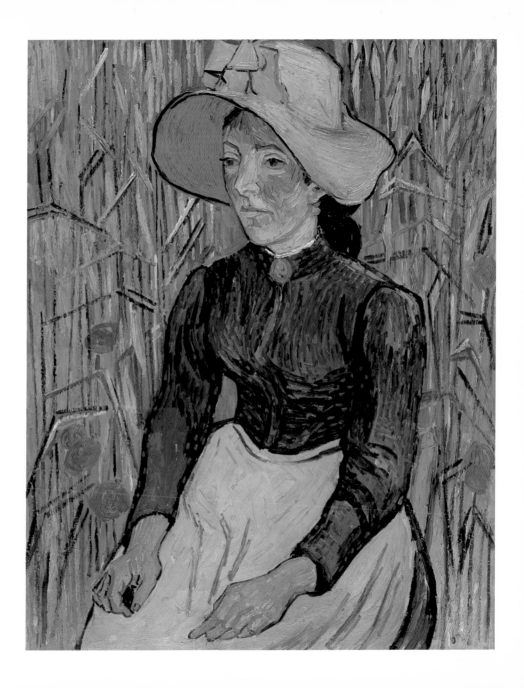

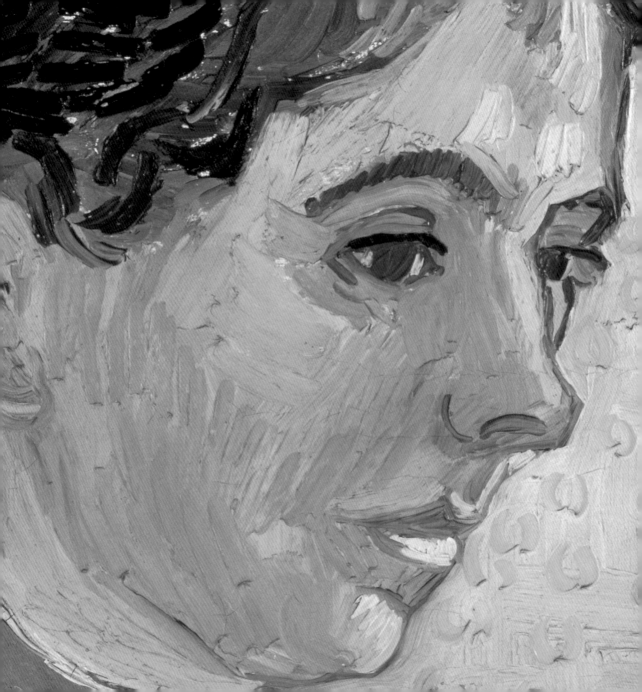

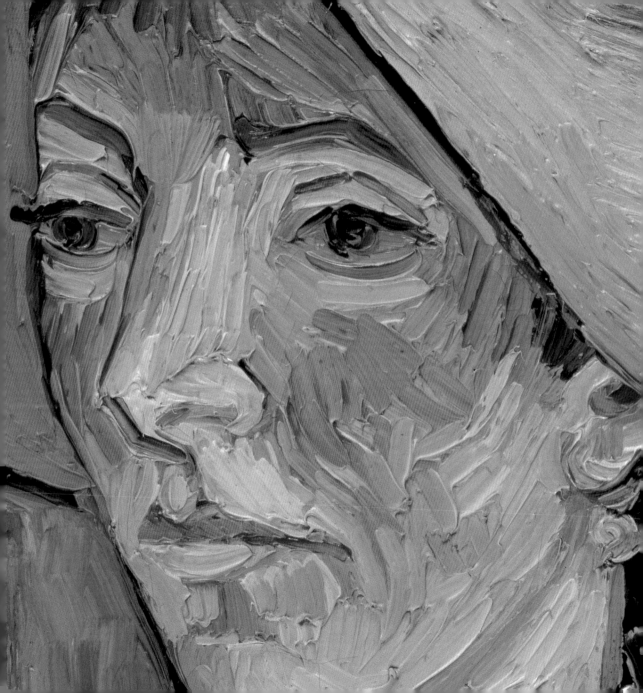

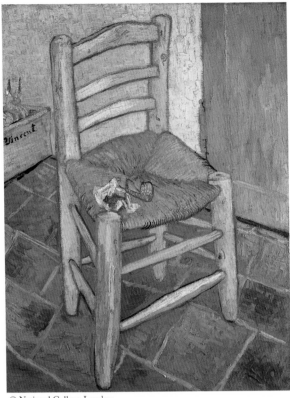

554. *Van Gogh's Chair,* 1888
(Detail), opposite page

© National Gallery, London

then as apparitions. By which I mean that I do not endeavour to achieve this by a photographic resemblance, but by means of our impassioned expressions—that is to say, using our knowledge of and our modern taste for color as a means of arriving at the expression and the intensification of the character." [LETTER W22] In van Gogh's eagerness to embrace life once more, "to see modern life as something bright, in spite of its inevitable griefs," [LETTER 617] he embraced humanity and attempted to fix its image, in color, with his brush.

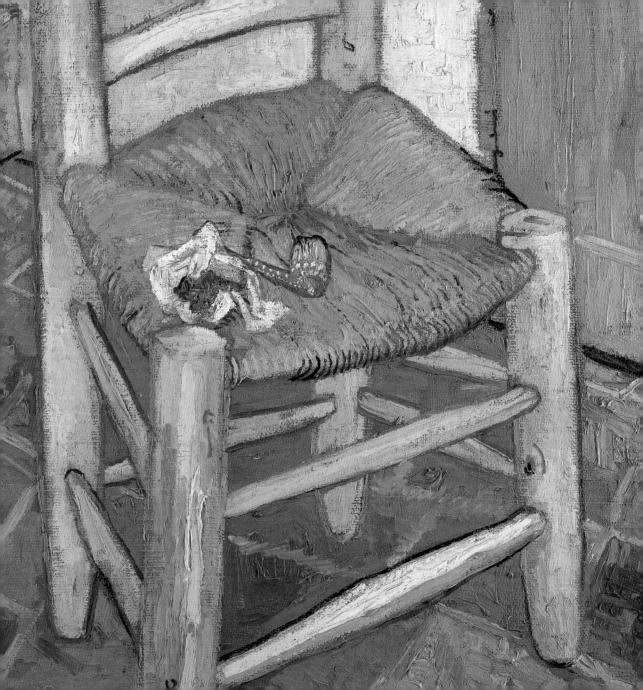

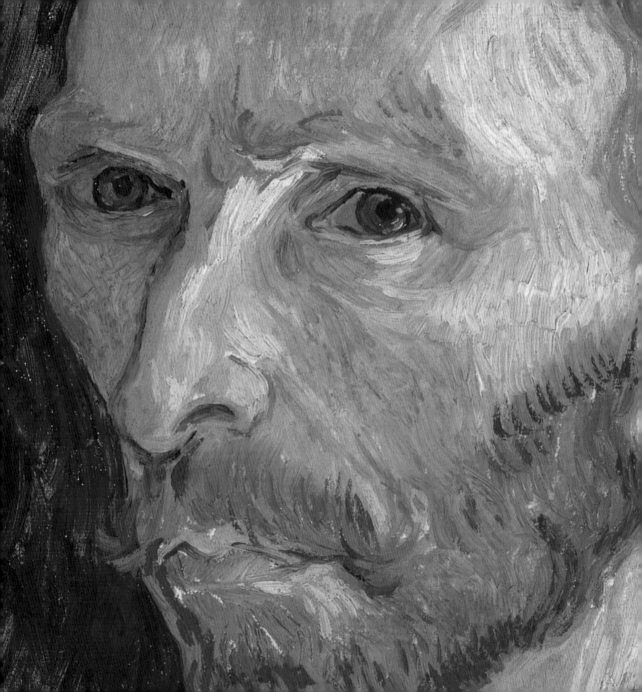

17, 19 *Head of a Peasant Woman with Red Bonnet,* 1885. Oil on canvas, 16¾ × 11½ in. (42.5 × 29.5 cm). Amsterdam, Van Gogh Museum (Vincent van Gogh Foundation).
F. 0160; JH. 0722

18, 20 *Head of a Peasant Woman with White Cap,* 1885. Oil on canvas, 16¾ × 14 in. (42.5 × 35.5 cm). Amsterdam, Van Gogh Museum (Vincent van Gogh Foundation).
F. 0388; JH. 0782

21 *Portrait of a Woman,* 1885. Pencil, black and red chalk on watercolor paper, 20 × 15½ in. (50.6 × 39.4 cm). Amsterdam, Van Gogh Museum (Vincent van Gogh Foundation).
F. 1357; JH. 0981

22 *Head of a Man,* 1886. Colored chalk on sketchbook paper, 13¾ × 10¼ in. (35 × 26 cm). Amsterdam, Van Gogh Museum (Vincent van Gogh Foundation).
F. 1244d; JH. 1158

23 *Self-Portrait,* 1887. Oil on canvas, 16 × 13 in. (41 × 33 cm). Collection Vincent van Gogh Foundation/Van Gogh Museum, Amsterdam.
F. 0356; JH. 1248

24 *Self-Portrait with a Gray Felt Hat,* 1886–87. Oil on cardboard, 16 × 12½ in. (41 × 32 cm). © Rijksmuseum, Amsterdam.
F. 0295; JH. 1211

25, 80 *Self-Portrait,* 1886–87. Oil on artist's board mounted on cradled panel, 16½ × 13¼ in. (42 × 33.7 cm). Joseph Winterbotham Collection. Photograph © 1999, The Art Institute of Chicago. All Rights Reserved.
F. 0345; JH. 1249

26, 28 *Portrait of Alexander Reid,* 1887. Oil on board, 16¼ × 13¼ in. (41.5 × 33.5 cm). Glasgow Museums: Art Gallery and Museum, Kelvingrove. © Glasgow Museums.
F. 0343; JH. 1250

26 *Self-Portrait with a Straw Hat,* 1887. Oil on canvas mounted on panel, 14 × 10½ in. (35.5 × 27 cm). City of Detroit Purchase, Photograph © The Detroit Institute of Arts.
F. 0526; JH. 1309

27, 29 *Self-Portrait with Grey Felt Hat,* 1887–88. Oil on canvas, 17¼ × 14¾ in. (44 × 37.5 cm). Amsterdam, Van Gogh Museum (Vincent van Gogh Foundation).
F. 0344; JH. 1353

30 *A Skull,* 1887–88. Oil on canvas on triplex, 16¼ × 12½ in. (41.5 × 31.5 cm). Amsterdam, Van Gogh Museum (Vincent van Gogh Foundation).
F. 0297a; JH. 1347

31 *Woman Sitting by a Cradle,* 1887. Oil on canvas, 24 × 18 in. (61 × 46 cm). Amsterdam, Van Gogh Museum (Vincent van Gogh Foundation).
F. 0369; JH. 1206

33 *Portrait of Père Tanguy,* 1887–88. Oil on canvas, 36¼ × 29½ in. (92 × 75 cm). © Musée Rodin.
F. 0363; JH. 1351

35, 37 *Italian Girl,* 1887. Oil on canvas, 32 × 23½ in. (81 × 60 cm). Musée d'Orsay. © Photo RMN-Hervé Lewandowski.
F. 0381; JH. 1355

36, 38 *The Zouave*, 1888. Oil on canvas, 25⅝ × 21¼ in. (65 × 54 cm). Amsterdam, Van Gogh Museum (Vincent van Gogh Foundation).
F. 0423; JH. 1486

39 *The Zouave (Bust)*, 1888. Ink on wove paper, 12⁹⁄₁₆ × 9⁹⁄₁₆ in. (31.9 × 24.3 cm). The Solomon R. Guggenheim Museum, New York. Thannhauser Collection, Gift, Justin K. Thannhauser, 1978. Photograph by David Heald. © The Solomon R. Guggenheim Foundation, New York.
F. 1482a; JH. 1535

40 *Postman Joseph Roulin*, 1888. Oil on canvas, 32 × 25¹¹⁄₁₆ in. (81.2 × 65.3 cm). Gift of Robert Treat Paine, 2nd. Courtesy, Museum of Fine Arts, Boston.
F. 0432; JH. 1522

41 *Portrait of Postman Roulin*, 1888. Oil on canvas, 25¼ × 19 in. (64 × 48 cm). Gift of Mr. and Mrs. Walter Buhl Ford II. Photograph © 1999 The Detroit Institute of Arts.
F. 0433; JH. 1524

41 *Portrait of Joseph Roulin, Bust*, 1888. Ink and chalk, 12½ × 9½ in. (32 × 24.4 cm). The J. Paul Getty Museum, Los Angeles.
F. 1458; JH. 1536

42, 46 *The Postman Roulin*, 1889. Oil on canvas, 25½ × 21¼ in. (65 × 54 cm). Collection Kröller-Müller Museum, Otterlo, The Netherlands.
F. 0439; JH. 1673

43 *Armand Roulin, Turned to Left*, 1888. Oil on canvas, 25⅝ × 21¼ in. (65 × 54 cm). Collection Museum Boijmans van Beuningen, Rotterdam.
F. 0493; JH. 1643

43 *Portrait of Camille Roulin*, 1888 or 1889. Oil canvas, 17 × 13¼ in. (43 × 35 cm). Philadelphia Museum of Art: Gift of Mr. and Mrs. Rodolphe Meyer De Schauensee.
F. 0537; JH. 1644

43 *Portrait of the Baby Marcelle Roulin*, 1888. Oil on canvas, 14 × 9½ in. (35.5 × 24.5 cm). Amsterdam, Van Gogh Museum (Vincent van Gogh Foundation).
F. 0441; JH. 1641

44 *Madame Roulin and her Baby*, 1888–89. Oil on canvas, 36⅜ × 28⅞ in. (92.4 × 73.3 cm). Philadelphia Museum of Art: Bequest of Lisa Norris Elkins.
F. 0490; JH. 1637

45, 47 *Portrait of a Peasant, (Patience Escalier)*, 1888. Oil on canvas, 25¼ × 21¼ in. (64 × 54 cm). Norton Simon Art Foundation, Pasadena, California.
F. 0443; JH. 1548

45 *Portrait of Eugène Boch, "The Poet,"* 1888. Oil on canvas, 23⅜ × 17¾ in. (60 × 45 cm). Musée d'Orsay. © Photo RMN-Hervé Lewandowski.
F. 0462; JH. 1574

49 *Self-Portrait with Bandaged Ear*, 1889. Oil on canvas, 23¾ × 19¾ in. (60.5 × 50 cm). The Courtauld Gallery, London.

50 *'La Berceuse' (Madame Roulin)*, 1888–89. Oil on canvas, 36¼ × 28¾ in. (92 × 73 cm). Collection Kröller-Müller Museum, Otterlo, The Netherlands.
F. 0504; JH. 1655

50 *Madame Roulin Rocking the Cradle (La Berceuse)*, 1889. Oil on canvas, 36½ × 29 in. (93 × 73.4 cm). Helen Birch Bartlett Memorial Collection, The Art Institute of Chicago.
F. 0506; JH. 1670

51, 52 *La Berceuse (Madame Roulin),* 1889. Oil on canvas, 36½ × 28 ¹¹⁄₁₆ in. (92.7 × 72.8 cm). Bequest of John T. Spaulding. Courtesy, Museum of Fine Arts, Boston.
F. 0508; JH. 1671

53, 55 *L'Arlésienne (Madame Ginoux),* 1888. Oil on canvas, 36⅝ × 29⅛ in. (93 × 74 cm). Musée d'Orsay, © Photo RMN-Gérard Blot.
F. 0489; JH. 1625

56, 74 *Self-Portrait,* 1889. Oil on canvas, 22½ × 17¼ in. (57 × 43.5 cm). Collection of Mr. and Mrs. John Hay Whitney. © 1999 Board of Trustees, National Gallery of Art, Washington.
F. 0626; JH. 1770

57, 75 *Self-Portrait,* 1889. Oil on canvas, 25½ × 21¼ in. (65 × 54 cm). Musée d'Orsay, © Photo RMN-Gérard Blot.
F. 0627; JH. 1772

59, 62 *Portrait of Trabuc,* 1889. Oil on canvas, 24 × 18¼ in. (61 × 46 cm). Kunstmuseum Solothurn, Dübi-Müller-Stiftung.
F. 0629; JH. 1774

60 *The Peasant (Gardener),* 1889. Oil on canvas, 24 × 19¾ in. (61 × 50 cm). Galleria Nazionale d'Arte Moderna e Arte Contemporanea, Roma.
F. 0531; JH. 1779

61, 63 *Portrait of Dr. Gachet,* 1890. Oil on canvas, 26¾ 22½ in. (68 x 57 cm). Musée d'Orsay, © Photo RMN-Gérard Blot.
F. 0754; JH. 2014

65 *Levert's Daughter with an Orange,* 1890. Oil on canvas, 19¾ × 20 in. (50 × 51 cm). Villa Flora Winterthur. Collection Arthur and Hedy Hahnloser.
F. 0785; JH. 2057

66 *Adeline Ravoux,* 1890. Oil on canvas, 20½ × 20½ in. (52 × 52 cm). © The Cleveland Museum of Art, 1999. Bequest of Leonard C. Hanna, Jr., 1958.31.
F. 0786; JH. 2036

67, 70 *The Little Arlésienne,* 1888. Oil on canvas, 20 × 19¼ in. (51 × 49 cm). Collection Kröller-Müller Museum, Otterlo, The Netherlands.
F. 0518; JH. 2056

68 *Marguerite Gachet at the Piano,* 1890. Oil on canvas, 40⅜ × 19⅝ in. (102.6 × 50 cm). Oeffentliche Kunstsammlung, Basel, Kunstmuseum. Photo: Oeffentliche Kunstsammlung, Basel, Martin Bühler.
F. 0772; JH. 2048

69, 71 *Peasant Woman Against a Background of Wheat,* June 1890. Oil on canvas, 36¼ × 28¾ in. (92 × 73 cm). Collection of the Bellagio Gallery of Fine Art.
F. 0774; JH. 2053

72, 73 *Van Gogh's Chair,* 1888. Oil on canvas, 36⅛ × 28¾ in. (91.8 × 73 cm). The National Gallery, London, England.
F. 0498; JH. 1635

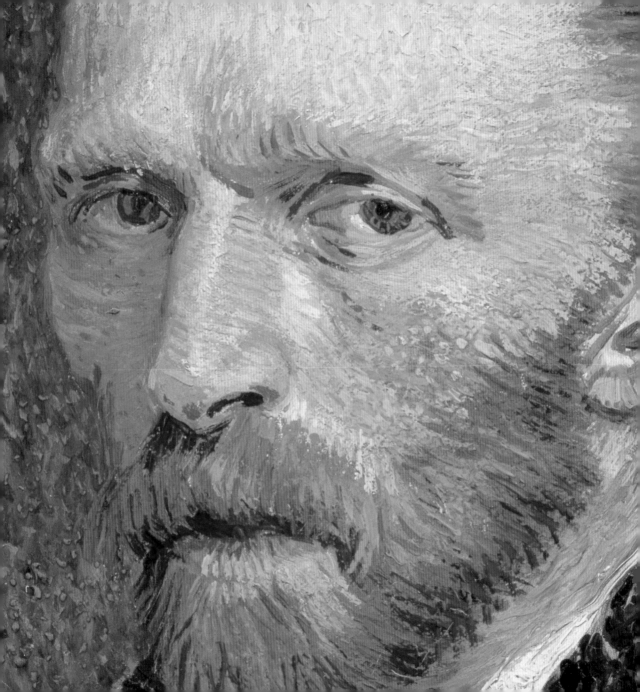

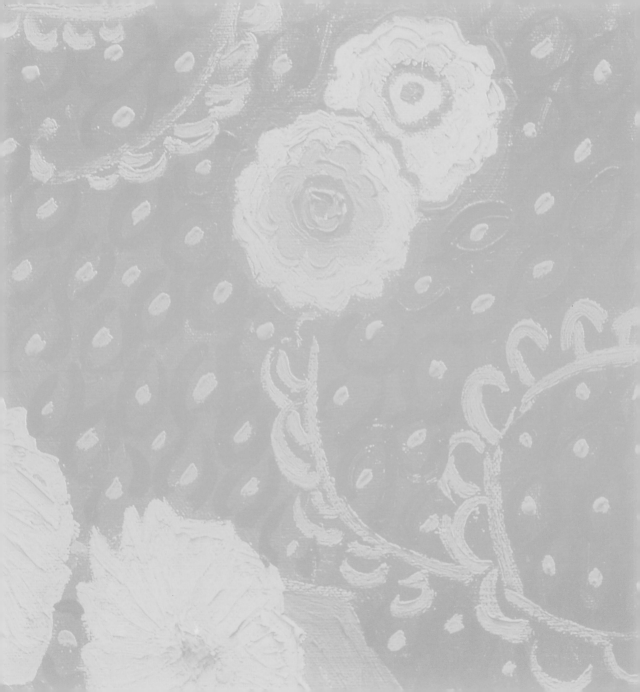